DRAW 50 | ALIENS

The Step-by-Step Way to Draw UFOs,
Galaxy Ghouls, Milky Way Marauders, and
Other Extraterrestrial Creatures

BOOKS IN THIS SERIES

DRAW 50 | ALIENS

The Step-by-Step Way to Draw UFOs, Galaxy Ghouls, Milky Way Marauders, and Other Extraterrestrial Creatures

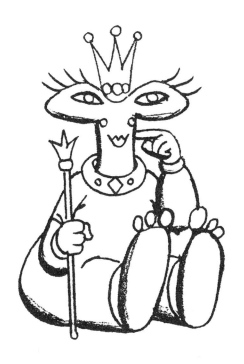

LEE J. AMES
with Ric Estrada

Watson-Guptill Publications, New York

Published in the United States by Watson-Guptill Publications,
an imprint of the Crown Publishing Group, a division of Random
House, Inc., New York, in 2013.

www.crownpublishing.com
www.watsonguptill.com

WATSON-GUPTILL and the WG and Horse designs are
registered trademarks of Random House, Inc.

Originally published in hardcover in the United States by
Doubleday, a division of Random House Inc., New York, in 1998.

Library of Congress Cataloging-in-Publication Data

Ames, Lee J.
 Draw 50 aliens, UFOs, galaxy ghouls, milky way marauders, and
other extraterrestrial creatures / Lee J. Ames with Ric Estrada.—
1st ed.
 p. cm.
 "A Main Street book."
Summary: A step-by-step guide to drawing outer space creatures.
1. Outer space—In art—Juvenile literature. 2. Drawing—
Technique—Juvenile literature. [1. Outer space—In art.
2. Drawing—Technique.] I. Estrada, Ric. II. Title.
NC825.09A43 1998
743'.8—dc21 98-20077
 CIP
 AC

ISBN 978-0-8230-8616-0
eISBN 978-0-8230-8617-7

Printed in the United States of America

10 9 8 7 6 5 4 3 2 1

For Loretta
and our eight wonders:
Aaron
Marc
Aleli
Bekah
Seth
Jeremy
Ethan
Hannah
and of course, Zilia
(Also a wonder!)

None of the above are extraterrestrial,
but all are out of this world!

Ric

My work includes children's book illustrations, articles for *Dance* magazine, *Spandauer Volksblatt* and *Sonne*, ghosting the *Flash Gordon* and *Spider Man* comic strips, political cartooning, innumerable comic books (*Superman*, *Batman*, *Wonder Woman*, *Sgt. Rock*, countless superheroes) and, in recent years, lots of TV advertising storyboards (Kodak, Breck, Alpo, U.S. Armed Forces, etc.) and cartoon animation for Hanna-Barbera, Warner Bros., DreamWorks and, currently, for Sony–Columbia–Tri-Star.

But my greatest adventure is my family—a wonderful wife and nine magnificent children bursting with talents and ambition.

I hope you enjoy drawing these extraterrestrial goonies as much as my good friend Lee Ames and I enjoyed dreaming them up.

Happy sketching!!!

—RIC ESTRADA

To the Reader

When you start working, use clean white bond paper or drawing paper and a pencil with moderately soft lead (HB or No. 2). Keep a kneaded eraser handy (available at art supply stores). Choose the alien you want to draw. Try to imagine the finished drawing on the drawing area. Then visualize the first steps so that the finished picture will nicely fill the page—not too large, not too small. Now, very lightly and very carefully, sketch out the first step. (These first steps are indicated in color for clarity. You can use a colored pencil crayon here if you prefer *or* a regular pencil.) Next, very lightly and carefully, add the second step, the third step, and so on. As you go along, study not only the lines but the spaces between the lines. Remember, the first steps must be sketched with the greatest care. A mistake here could ruin your final drawing.

As you work, it's a good idea, from time to time, to hold a mirror to your sketch. The image in the mirror frequently shows distortion you might not recognize otherwise.

In the book you will notice that the new step additions (in color) are printed darker so they can be clearly identified. But be sure to keep all of your construction steps very light. Here's where the kneaded eraser can be useful. You can lighten a pencil stroke that is too dark by pressing on it with the eraser.

When you've completed all the light steps, and when you're sure you have everything the way you want it, finish your drawing with firm, strong pencil strokes. If you like, you can go over this with India ink (applied with a fine brush or pen) or a permanent fine-tipped ballpoint pen or a felt-tipped marker. When thoroughly dry, you can then rub the kneaded eraser over the entire surface to clean out all the underlying pencil marks.

Remember, if your first attempts at drawing do not turn out the way you'd like, it's important to *keep trying*. Your efforts will eventually pay off and you'll be pleased and surprised at what you can accomplish. I sincerely hope, as you follow our techniques, that your skills will improve. Following the way Ric and I work and then exercising your thinking tools can open the door to your own creativity. We hope you will enjoy drawing our extraterrestrial friends.

LEE J. AMES

DRAW **50** ALIENS, UFOs, GALAXY GHOULS, MILKY WAY MARAUDERS, AND OTHER EXTRATERRESTRIAL CREATURES

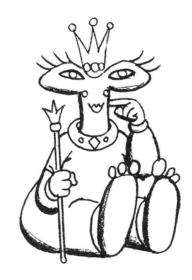

UFOs

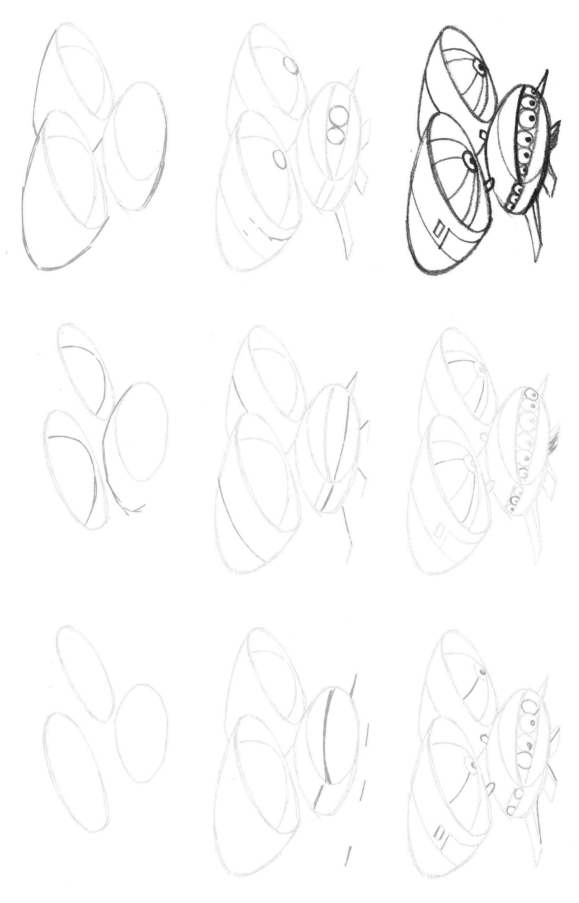

PUDDDEL
Primary Ultra 3 Dimensional Elevator, propelled by enormous twin laser beamatrons.

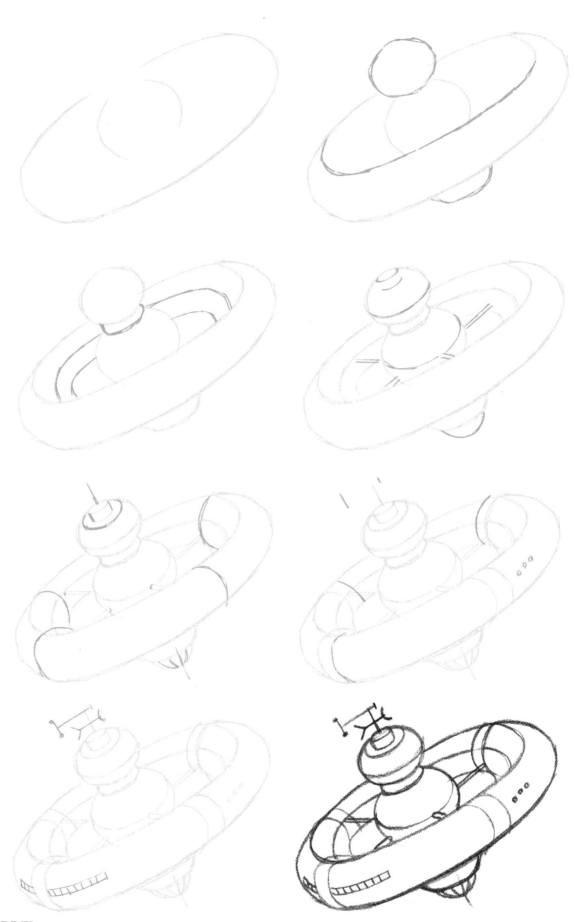

MUDDDDEL

Major Ultra 4th Dimensional Elevator. Transports population of two to three villages.

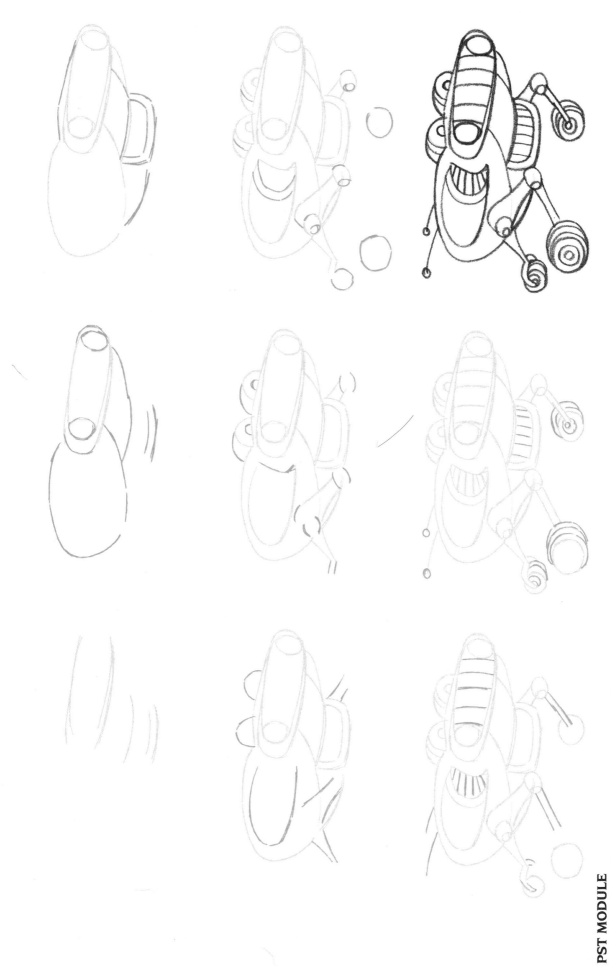

PST MODULE
Principal Stellar Transportation. Official personnel carrier with huge, rolling landing gear.

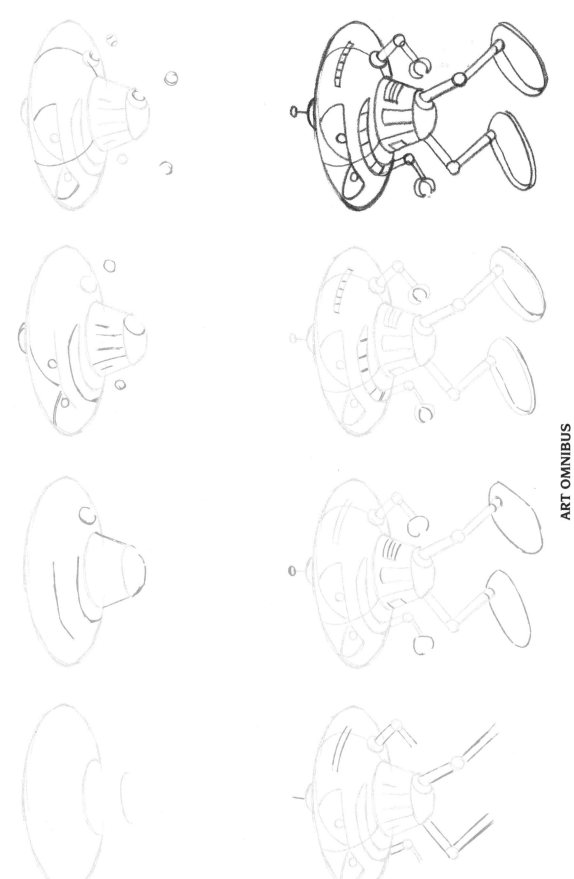

ART OMNIBUS

Arcturus Rapid Transit. Enormous robot troop carrier with retractable "feet" landing gear.

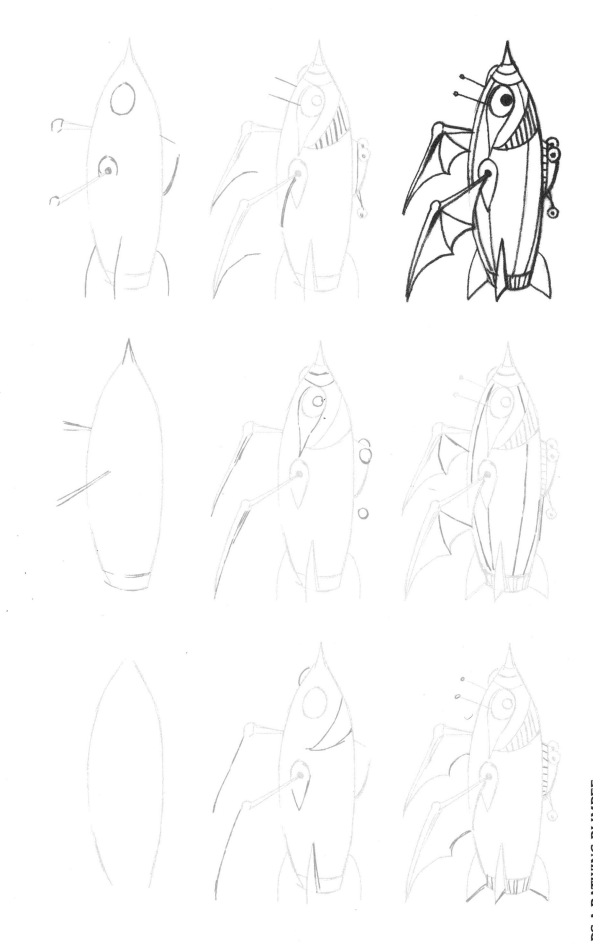

IOT-PS A BATWING BLIMPEE
An Inter-Orbit Ten Passenger Shuttle yet to be discovered.

THE GREYS

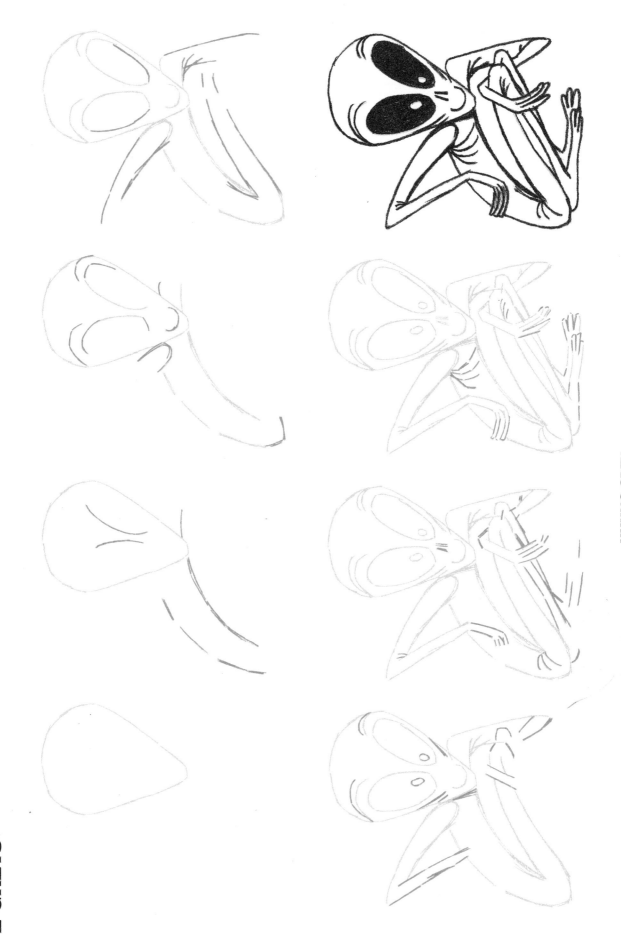

HUHNG GREY
Common gaunt Grey spotted near Route 375 in Arizona. Home unknown.

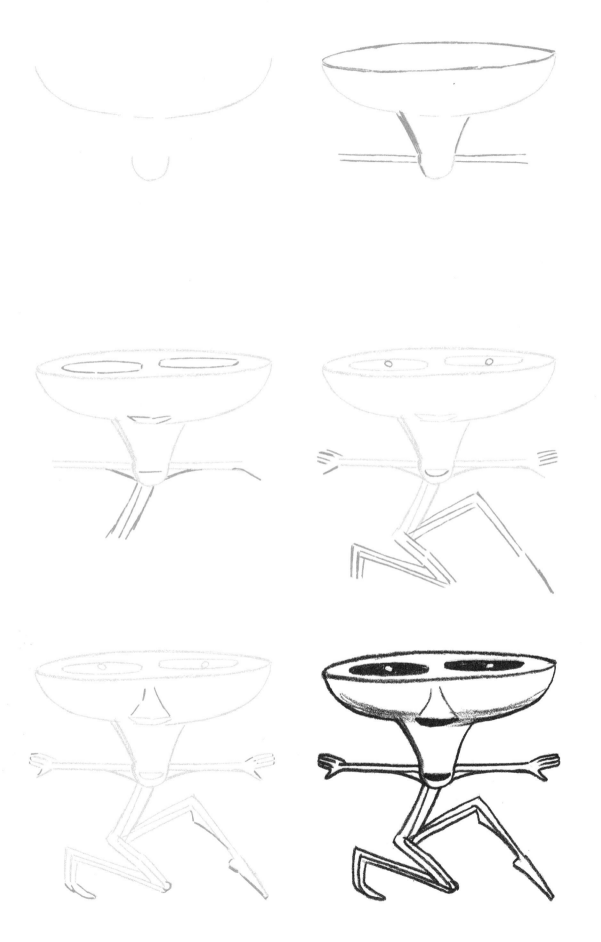

LEV EL HEDDID
Sensible, even-tempered visitor from vicinity of Fum al Samakah.

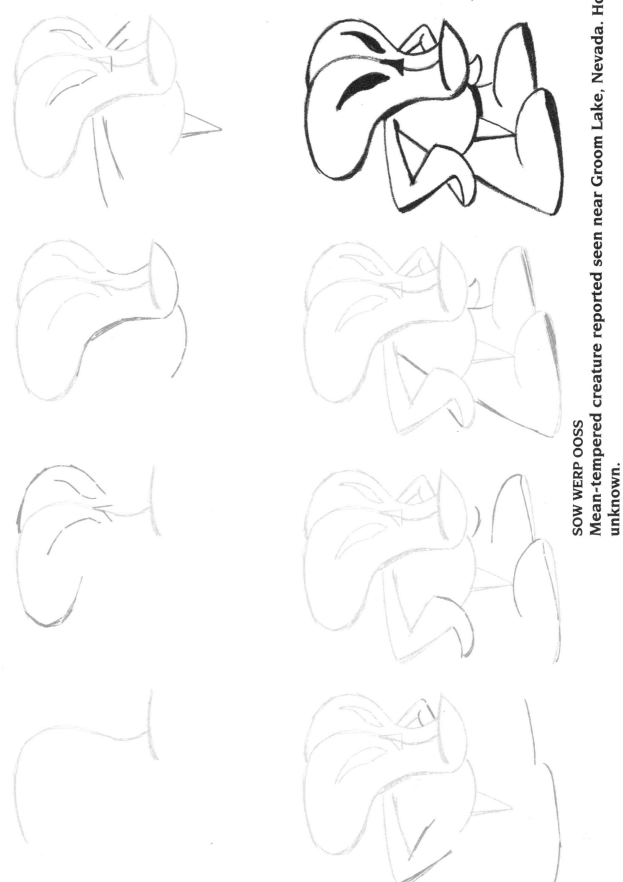

SOW WERP OOSS
Mean-tempered creature reported seen near Groom Lake, Nevada. Home unknown.

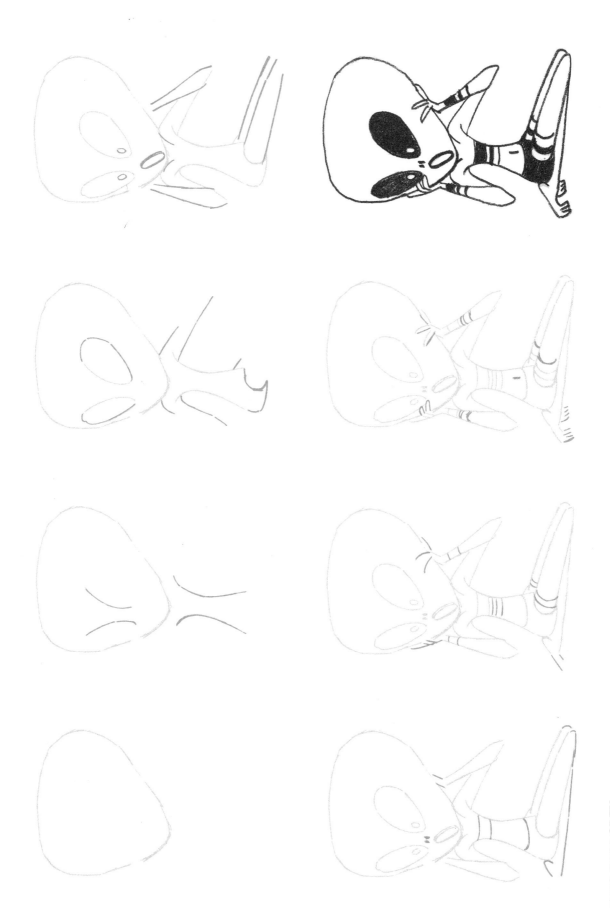

GLAMM OORG EARLGREY
Guest also from Fum al Samakah. Feeds on tea-like nutrient.

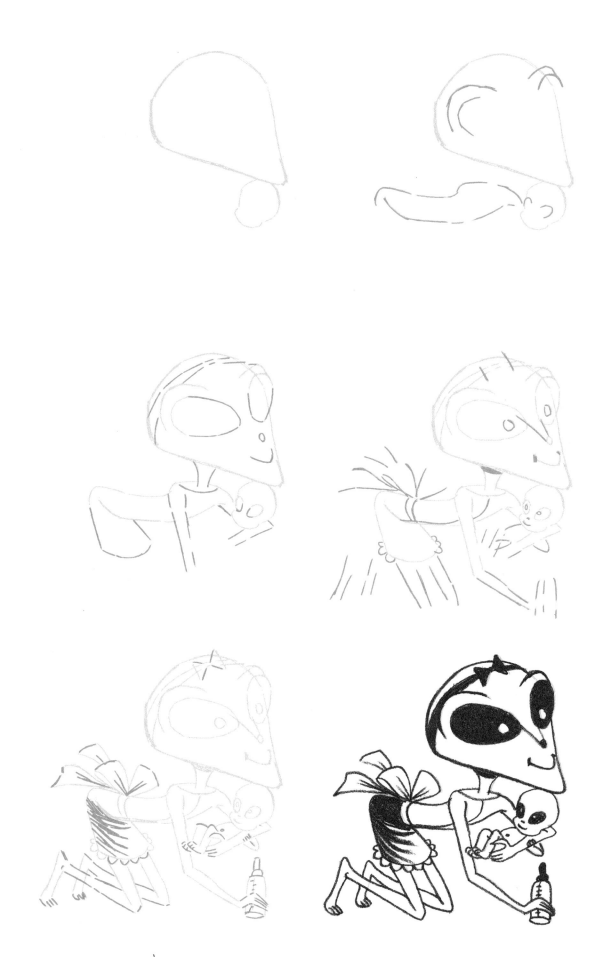

PEARL AND MOTHER OF PEARL
Two Fum al Samakah Pearl Greys.

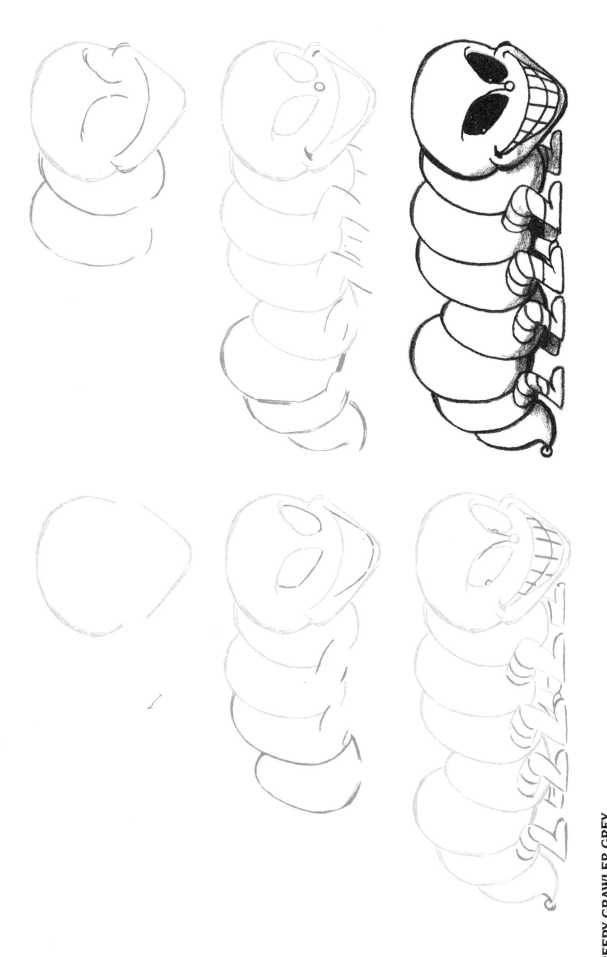

GREEPY GRAWLER GREY
Tiny multiped seen crawling off foot of Sow Werp Ooss.

GALAXY GHOULS

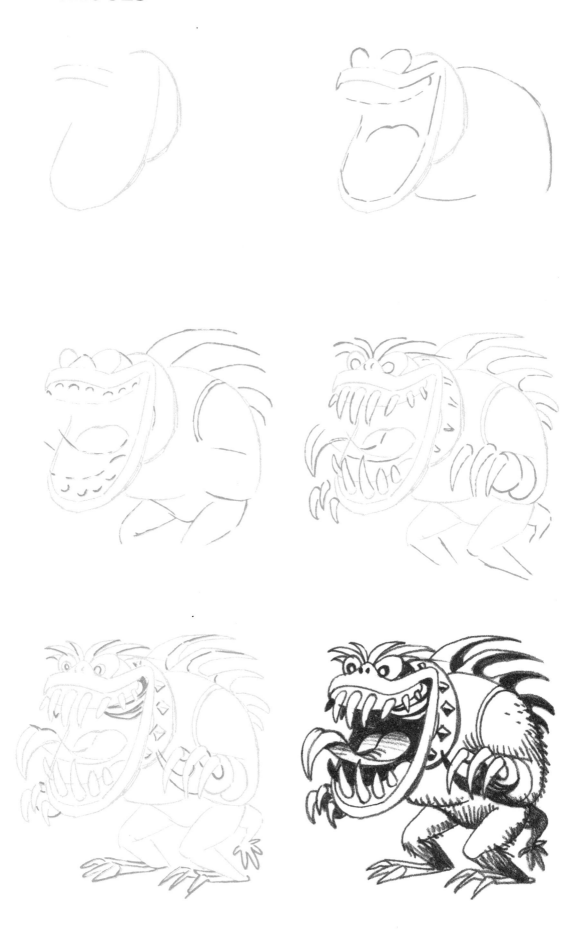

GABBA GHOUL
Ham actor from theater complex in Orion.

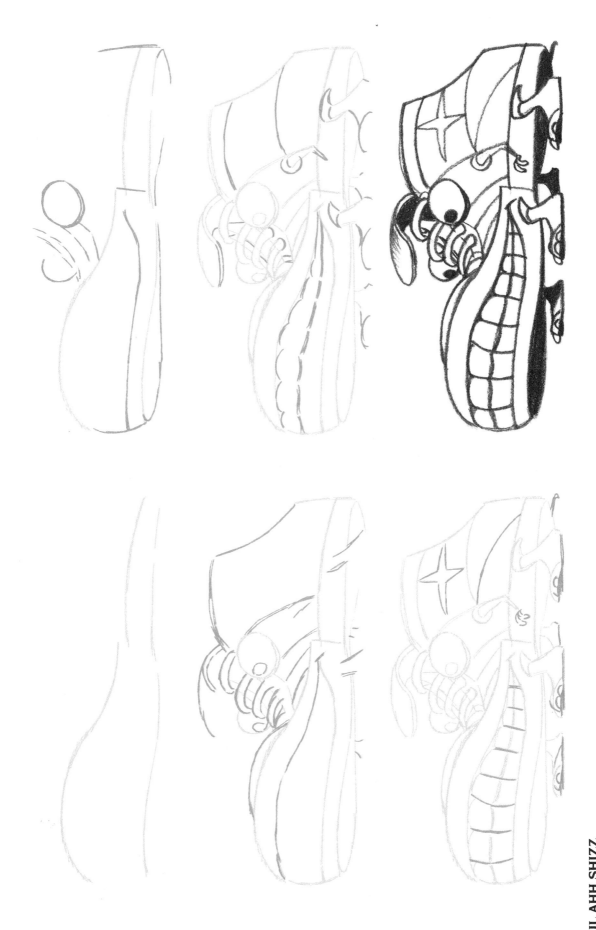

GHOUL AHH SHIZZ
Doomed hiker from unknown frozen region.

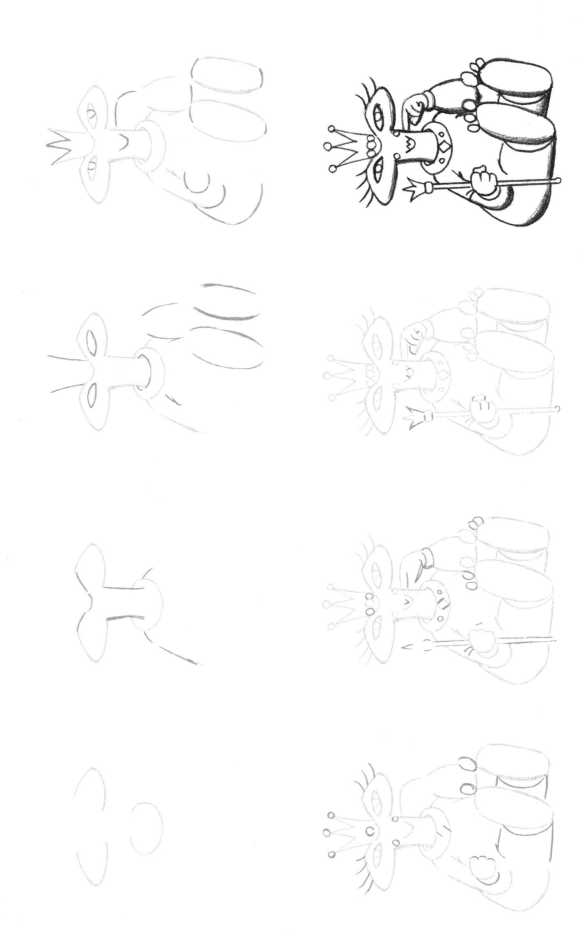

GHOUL DRINKA WATR
Naïve princess of minor Naos planet.

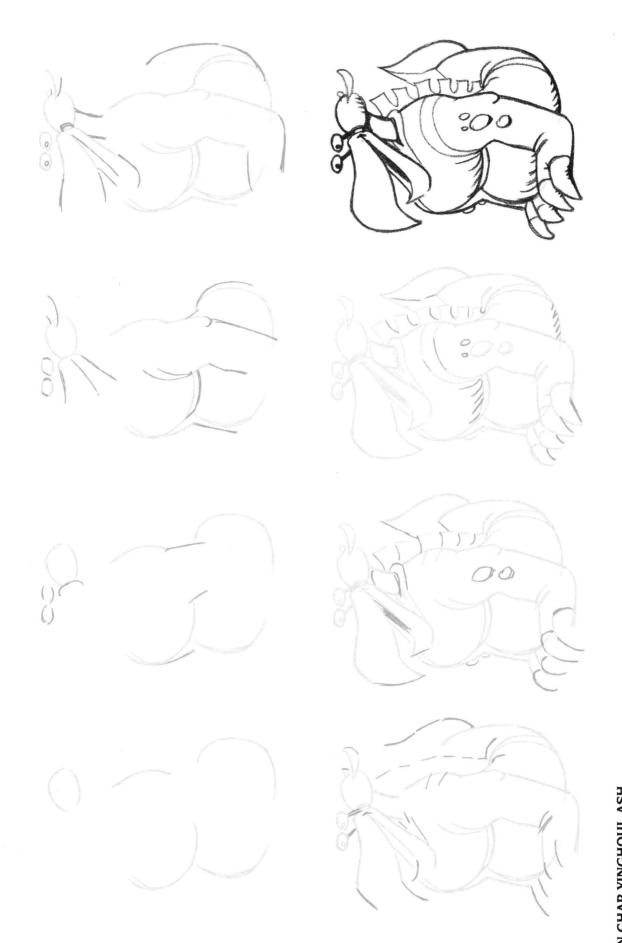

HUHN GHAR YINGHOUL ASH
Peppery tourist from Thuban's fourth planet.

NEBULA NOMADS

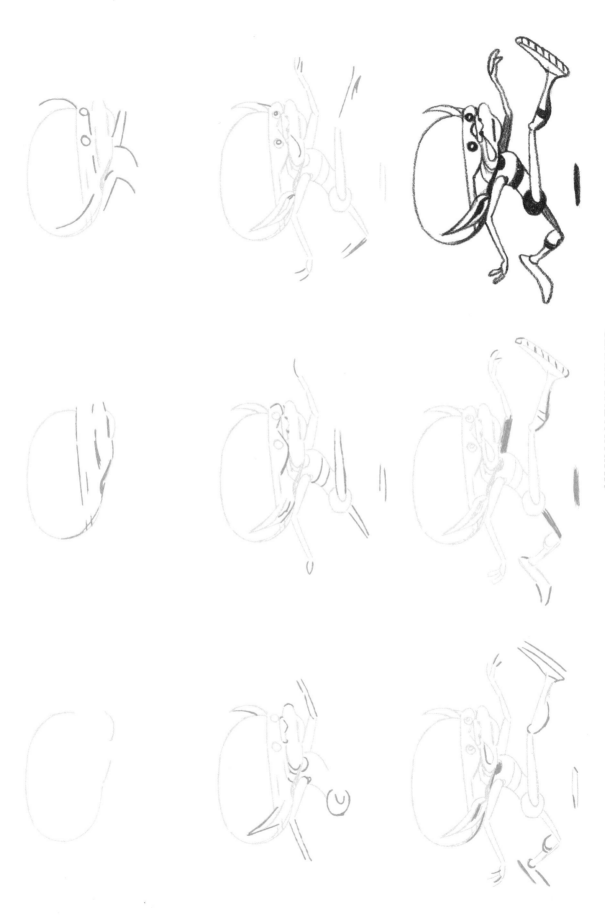

AH YAMMAFAH RUNNER
Champion long-distance runner from neighborhood of Betelgeuse.

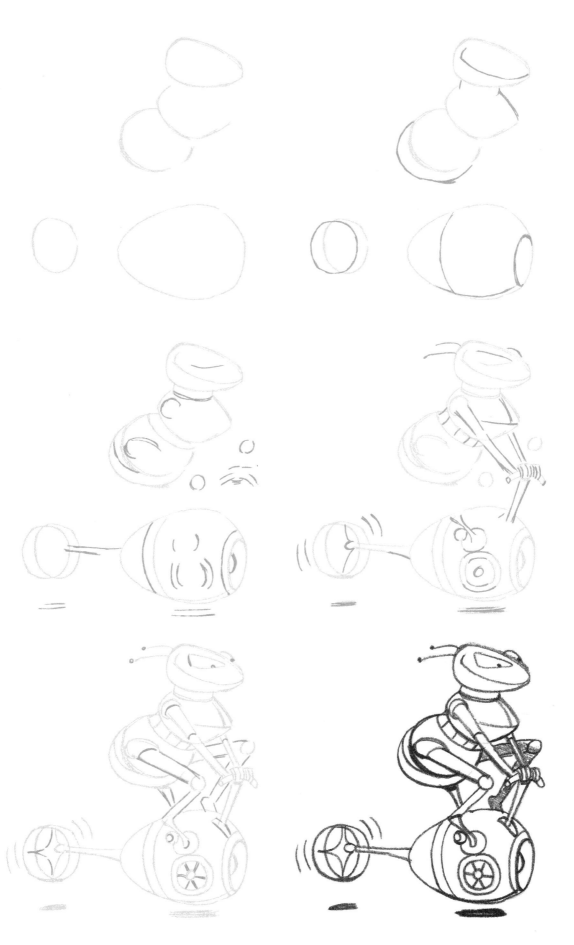

RYE DIMM KA-OOBUOY
Herder of the Porrima star system's food conveyors.

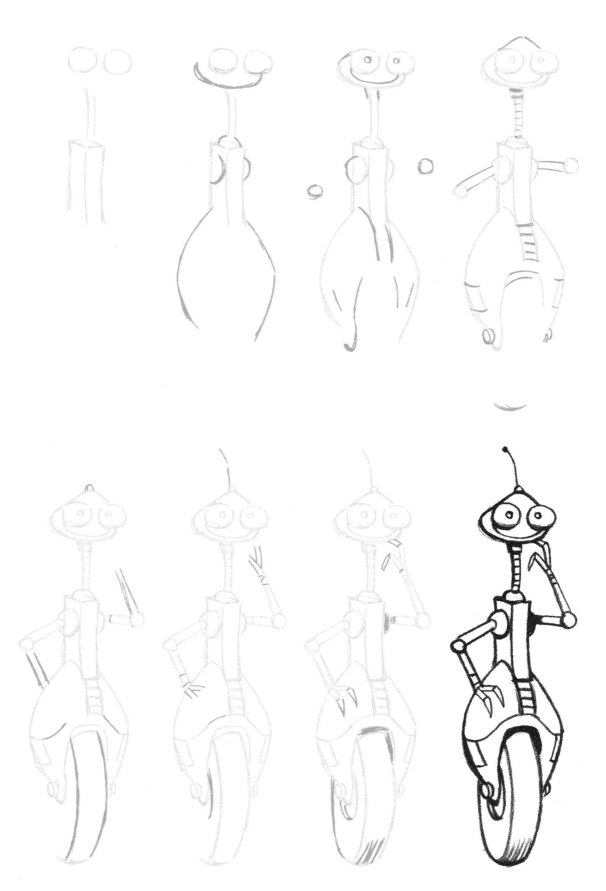

ROHV INGG KA-OOBUOY
Assistant to Rye Dimm Ka-oobuoy.

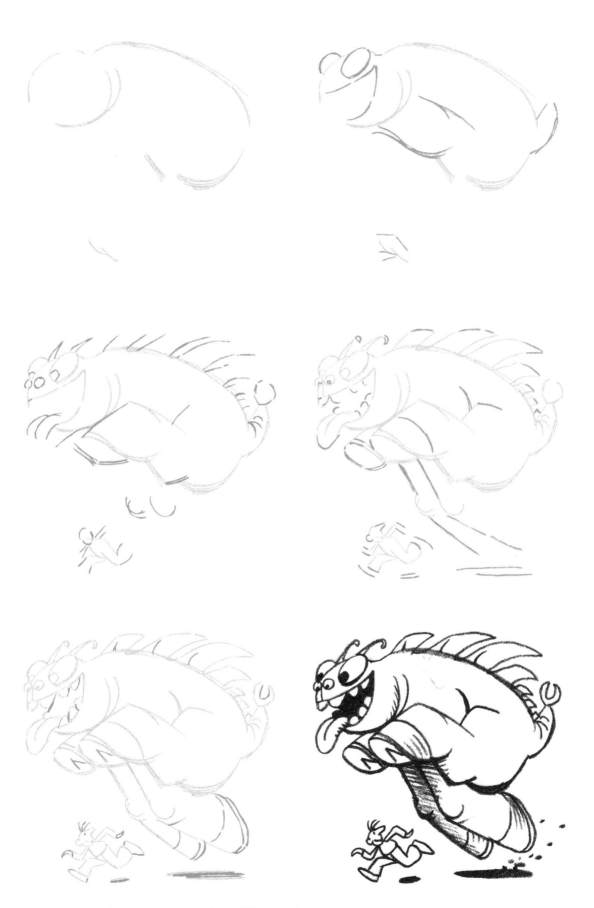

HOPP AHLONG KAZZADEECH
Last friendly nomad from unknown star system observed in the Bronx, New York.

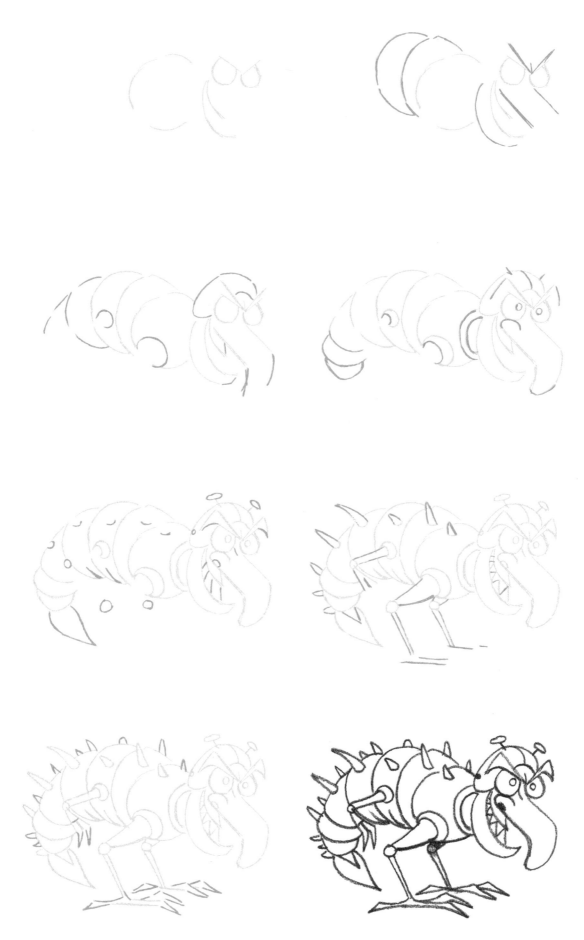

KRIMM INILK ROOK
An escaped, wandering thief from an unknown galaxy penitentiary.

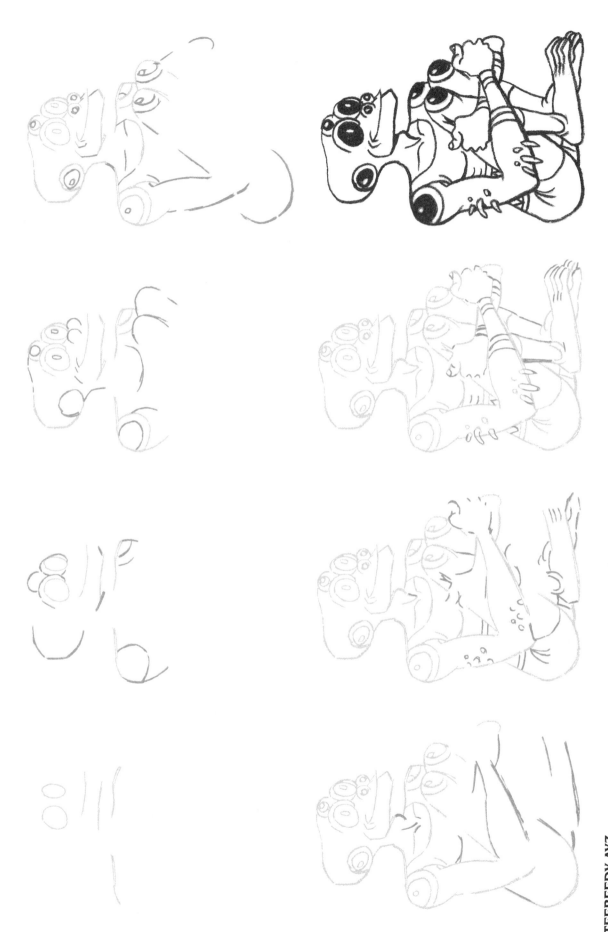

MULL TEEBEEDY AYZ
Interloper from unknown galaxy. All-seeing nomad but dim-witted!

MILKY WAY MARAUDERS

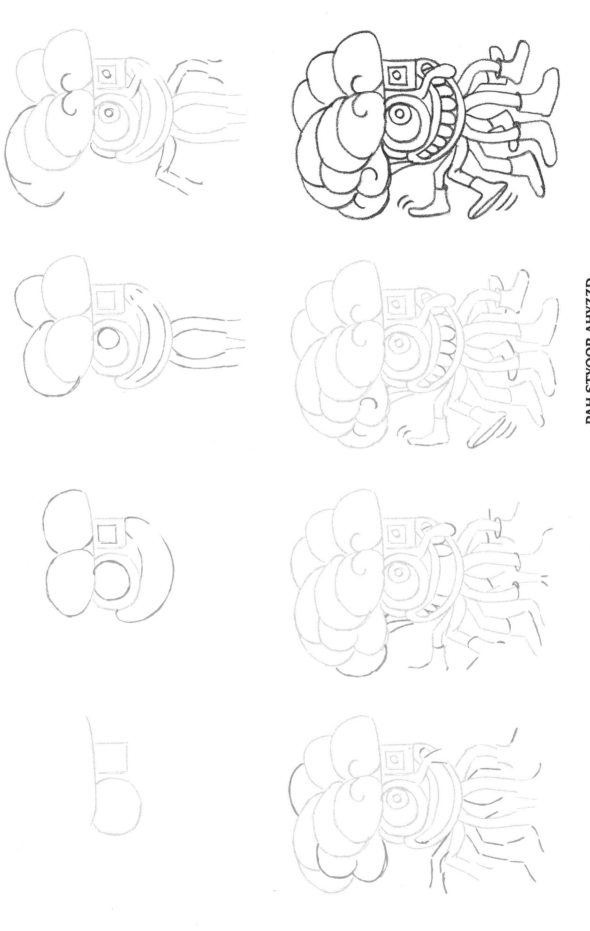

PAH STYOOR AHYZZD
"Purified" native of moon circling third planet of Etamin.

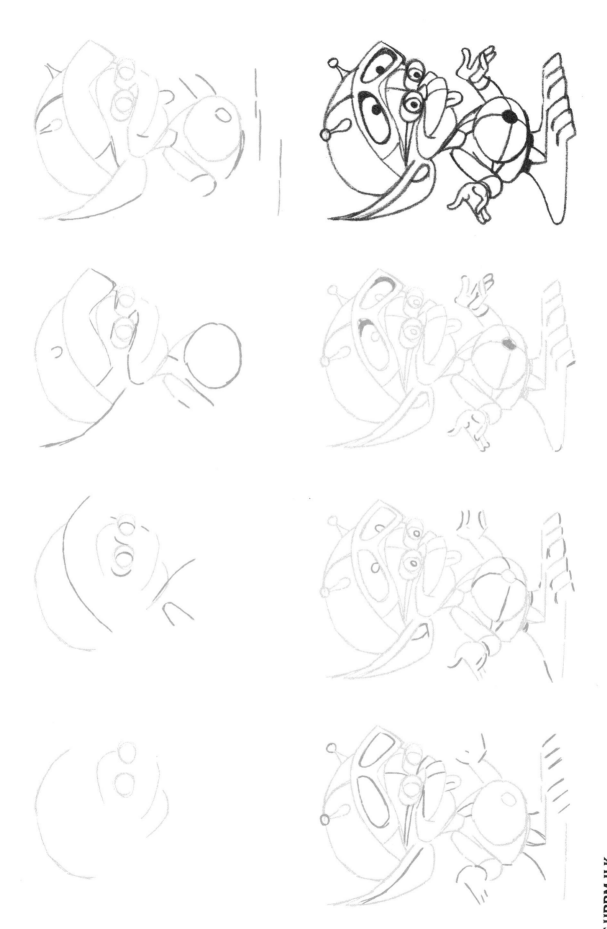

BUHTT URRM ILK
Pale yellow segmented crafty creeper from nebula NGC 2440.

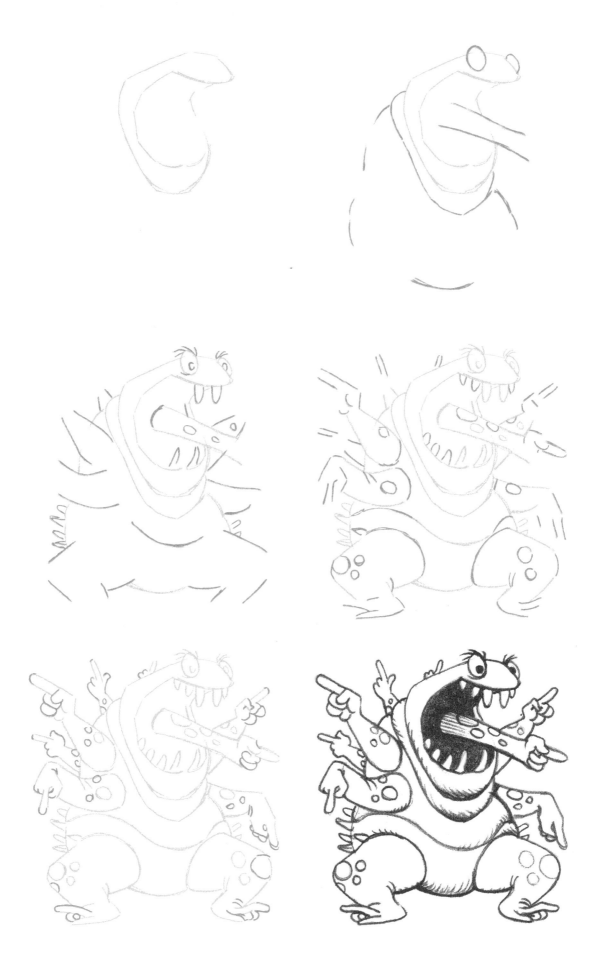

CAM M. BEAR
Foul-smelling tongue pointer from the Little Dumbbell nebula.

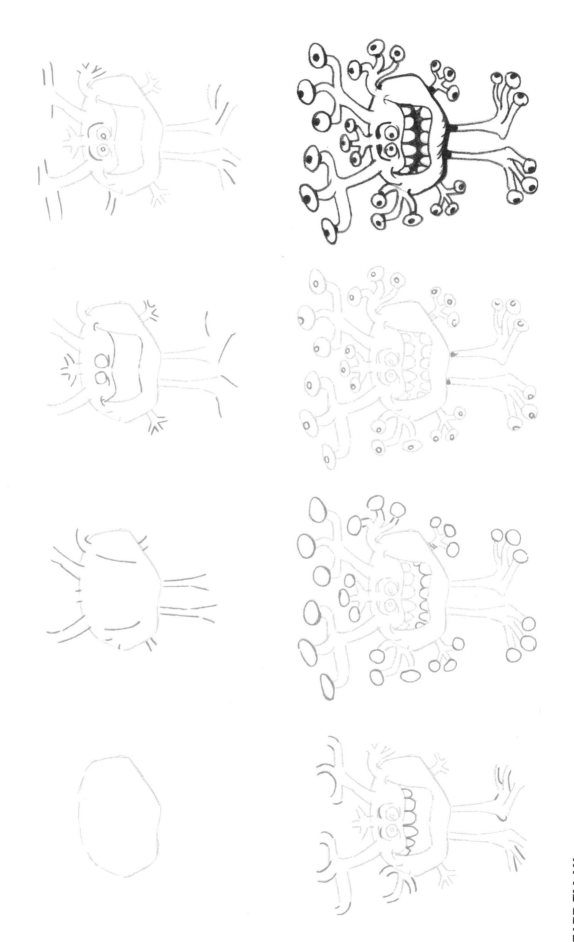

MUTTZARR ELLAH
Stringy parolee from a Tania Borealis reformatory.

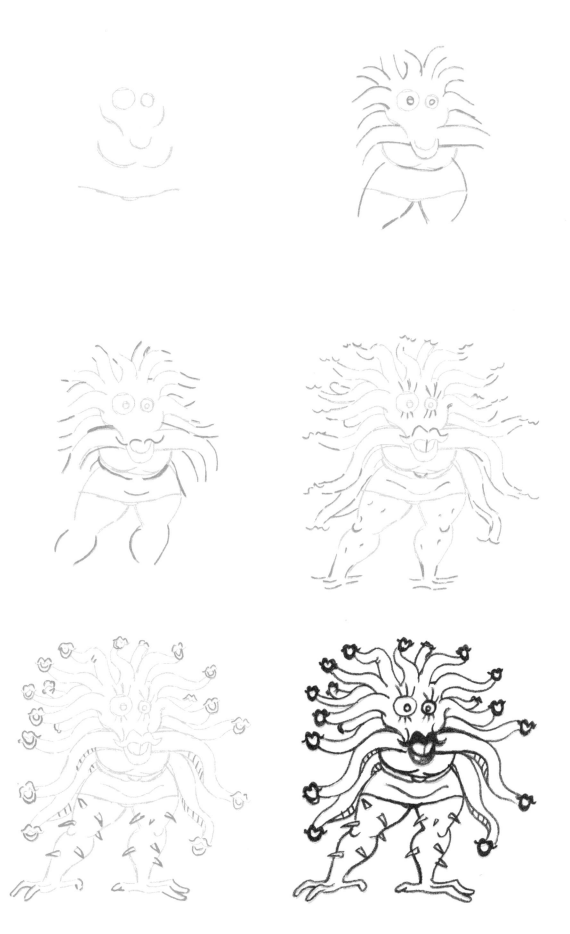

PAR MIZH AHN
A relative of Muttzarr Ellah.

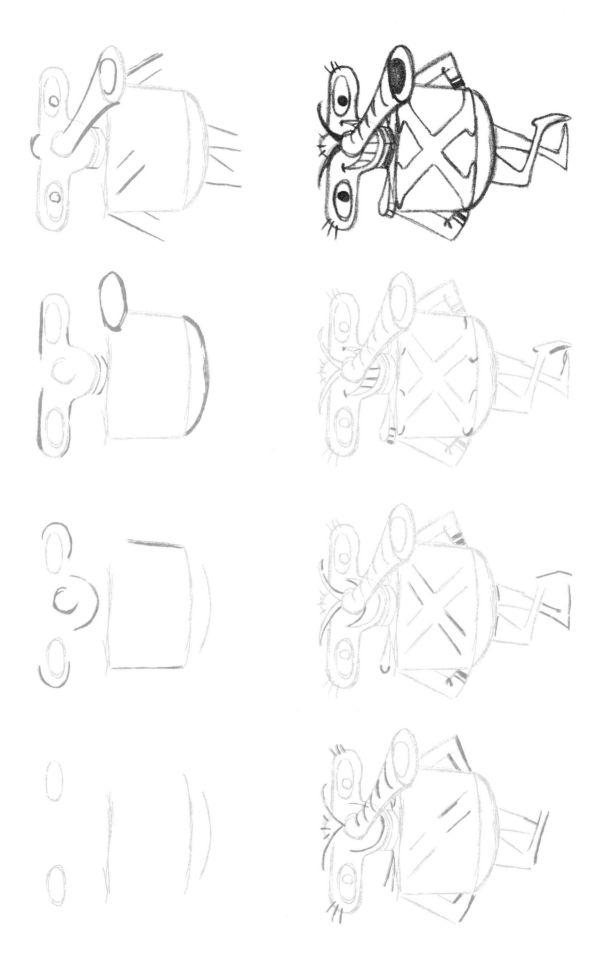

FEYT AHCH EEZ
An "old salt" from the El Nath star system.

P. CHIZZANK REEM
Very pleasant organism with a sweet smile found in our galaxy.

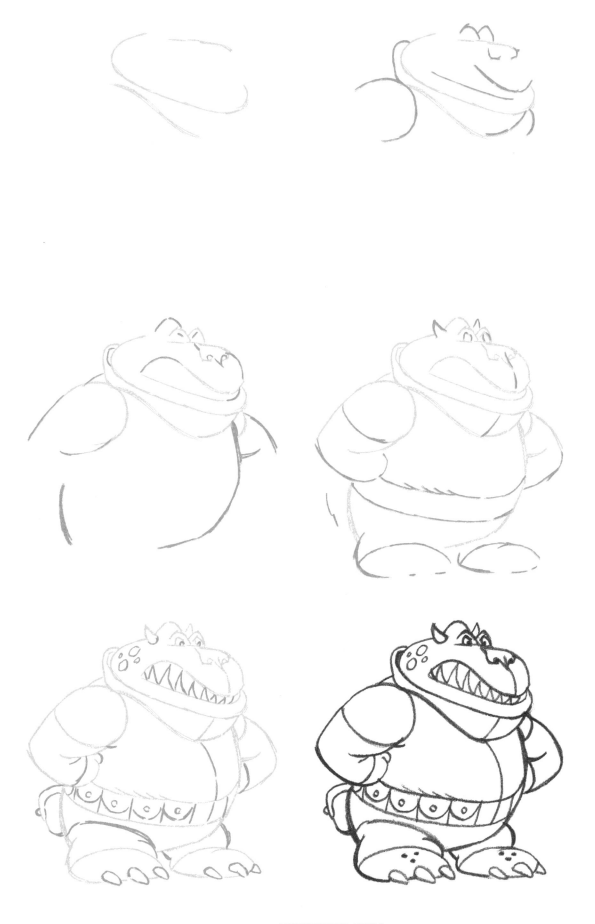

BUH TURB AWLL
Noisy, fatty visitor from one of Antares' planets.

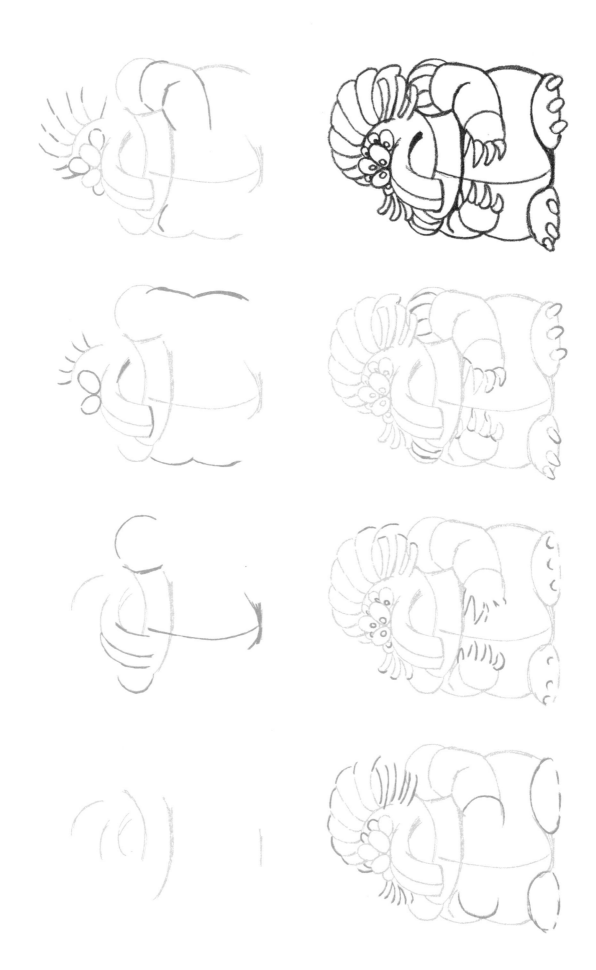

GORGHONN ZOLA
Smelly, savory, spaced-out nanny.

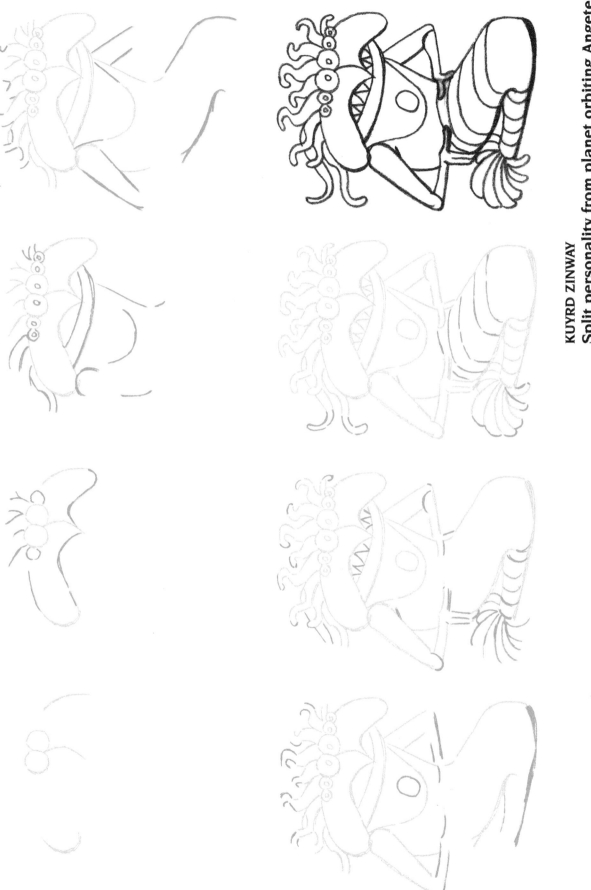

KUYRD ZINWAY
Split personality from planet orbiting Angetenar.

KAHFI YISE KREEM
A luscious, keyed-up guest from the vicinity of the star Vega.

COSMIC MARAUDERS

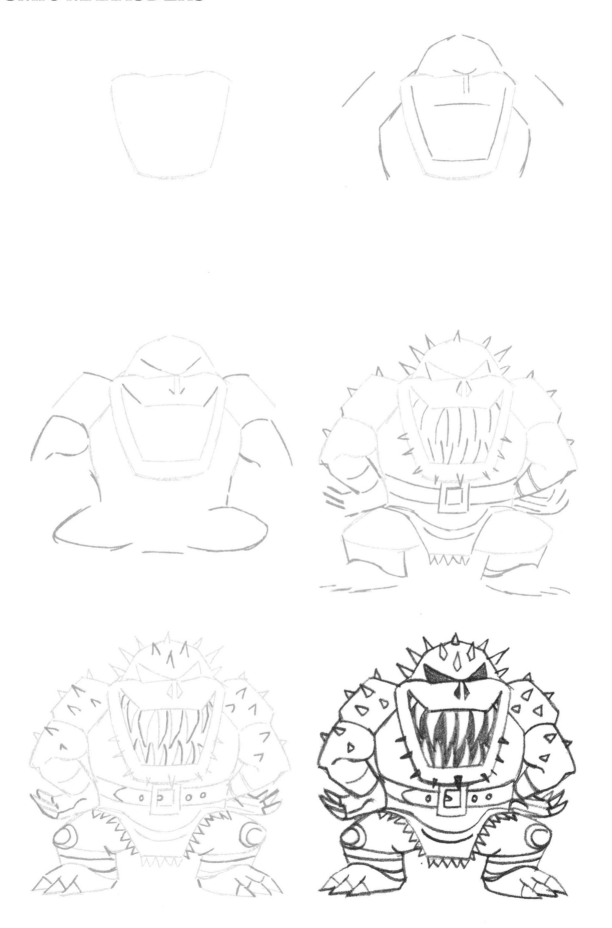

DEE PROOOTCANN AL
The terrible, toothy tickler from an unknown planet in the Eskimo nebula.

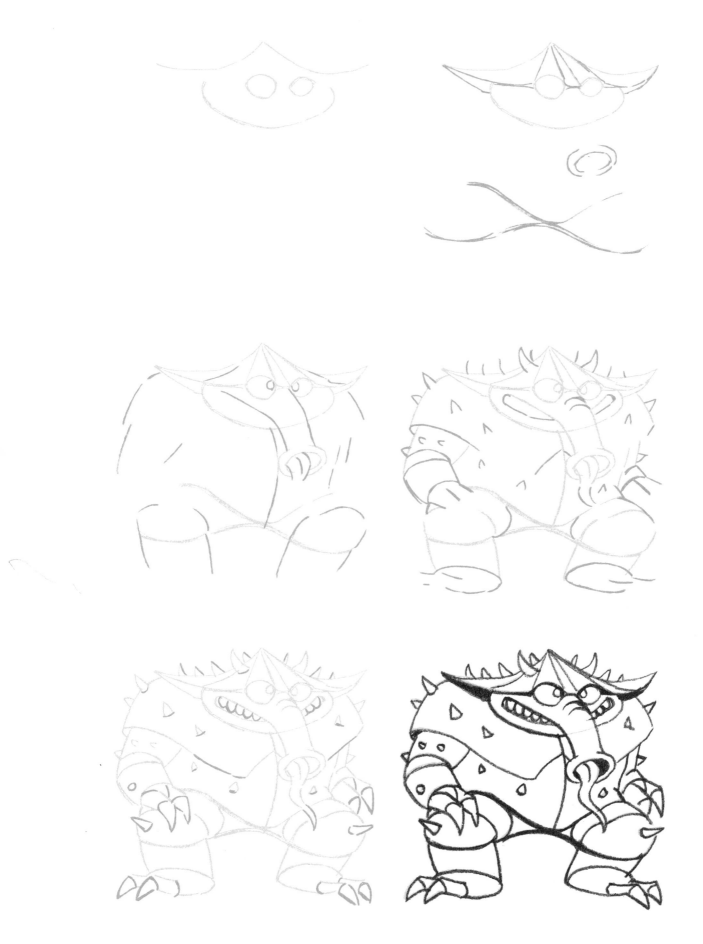

NAYZZEL LIKKINHULK
A savage from the environment of the Oort cloud.

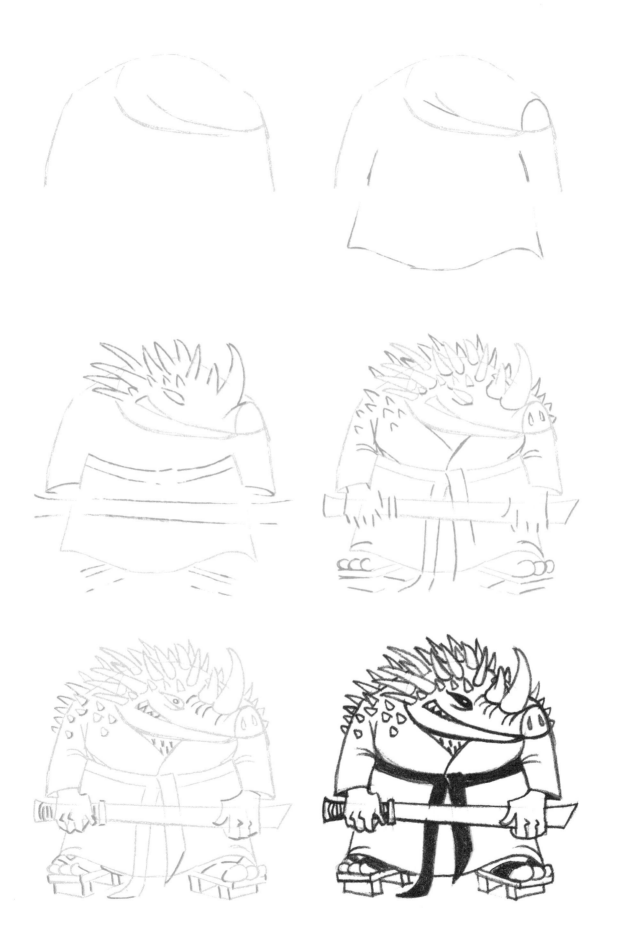

HAKK IMUPPIN WEEBITZ
The horrible hacker from the Horsehead galaxy.

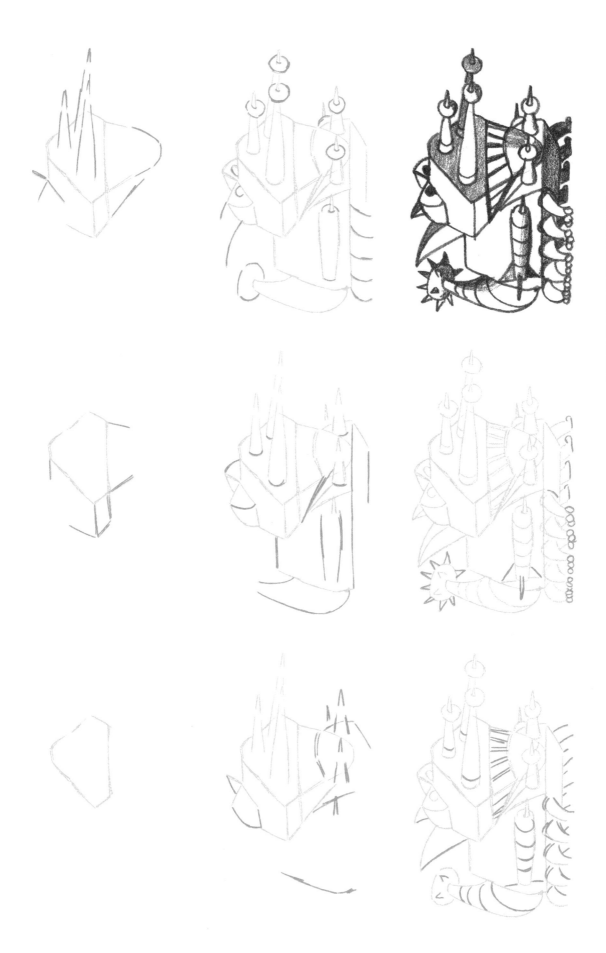

GUNGALORE SENTIPEEDUS
A "hired gun" from the constellation Cassiopeia.

ETCs (EXTRATERRESTRIAL CURIOSITIES)

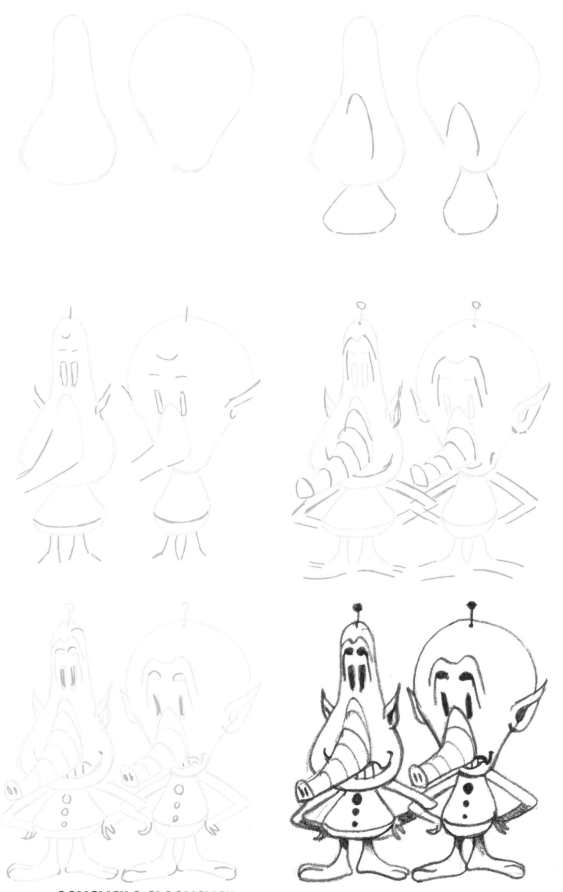

OOMGLICK & GLOOMCLICK
Orphans, fraternal, trunk-nosed twins, from locality of an unknown dwarf star.

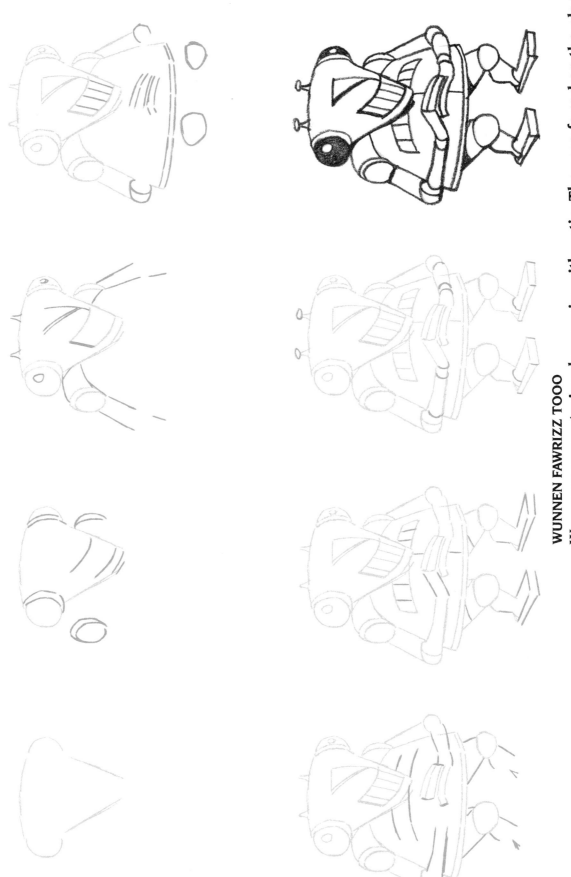

WUNNEN FAWRIZZ TOOO
Wunnens are notoriously poor in arithmetic. They are found on the planet of Zosma.

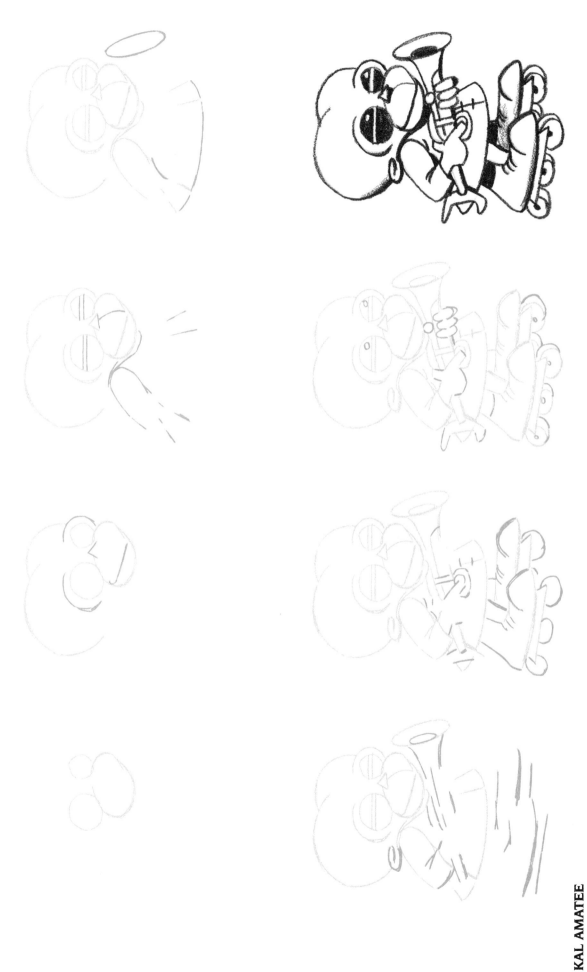

KAL AMATEE
Pear-headed tramp with blunderbuss–like weapon. Native of planet circling Nodus Secundus.

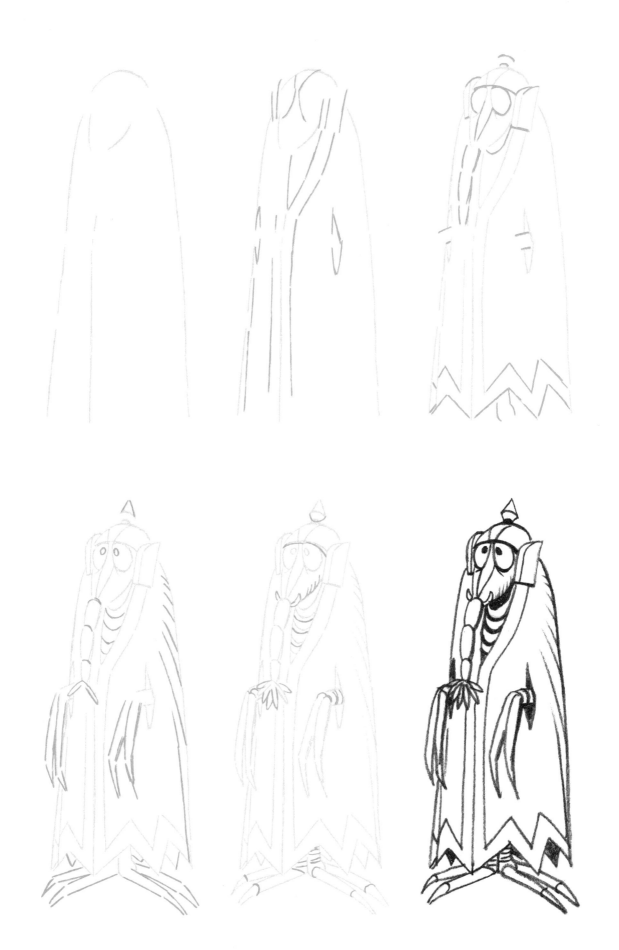

MAJOR DIZZ ASTIR
Woeful spike-headed wimp from Tania Australis.

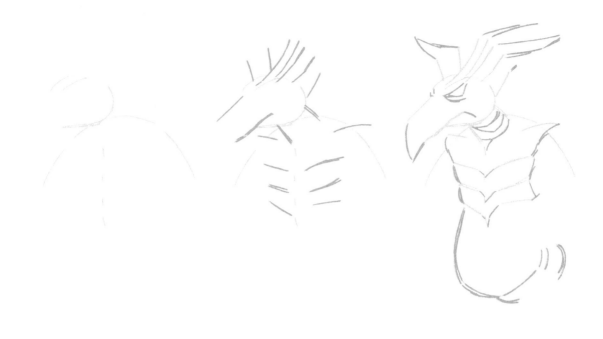

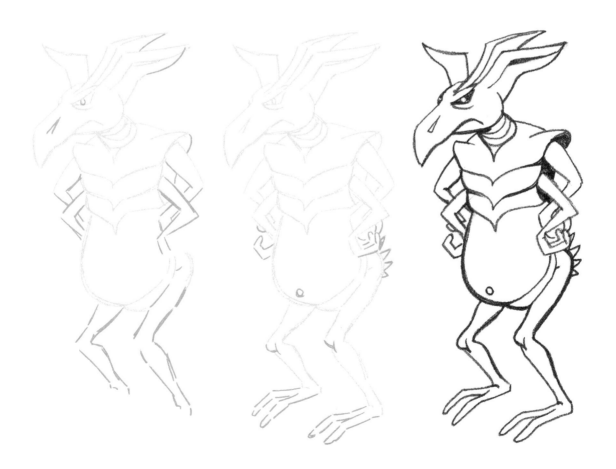

GOFUDDL YIRDUDDL
Common insulting driggo out of the Tejat Posterior.

AITCH EYE JAYKAYE
A domesticated Jaykaye; common pet found in the Little Dumbbell nebula.

LAKOO KAROTSHA
Tiny vermin pest unearthed on remote planet in the Crab nebula.

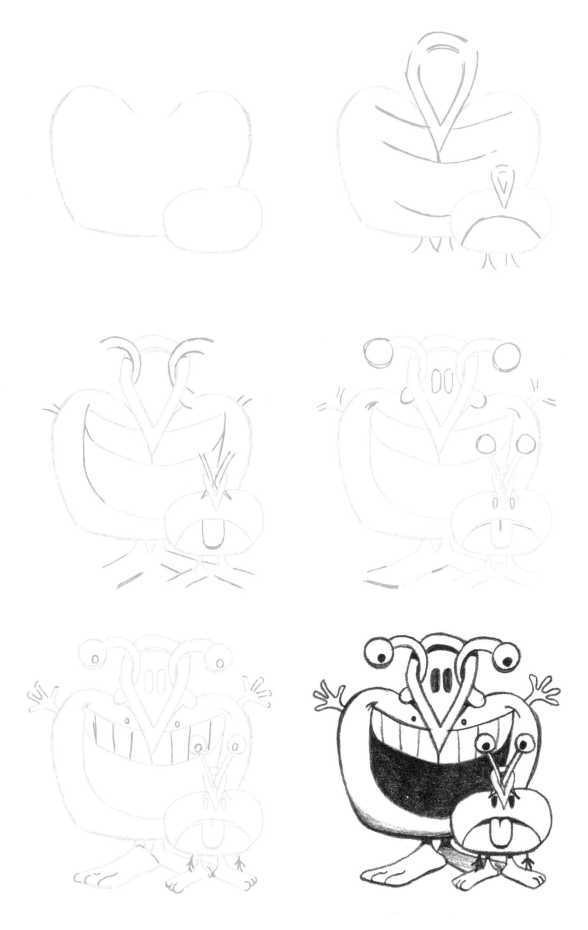

GOGGLE GLEE & GOGGLE GLUM
Green gobloons from Grus.

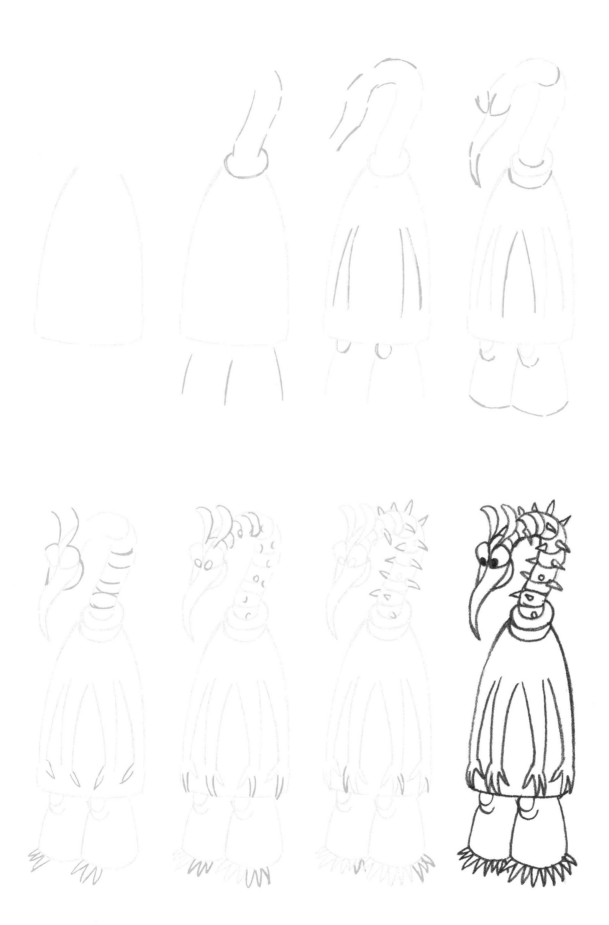

STUMM EHKAKE
A spike-necked gork from the constellation Aquarius.

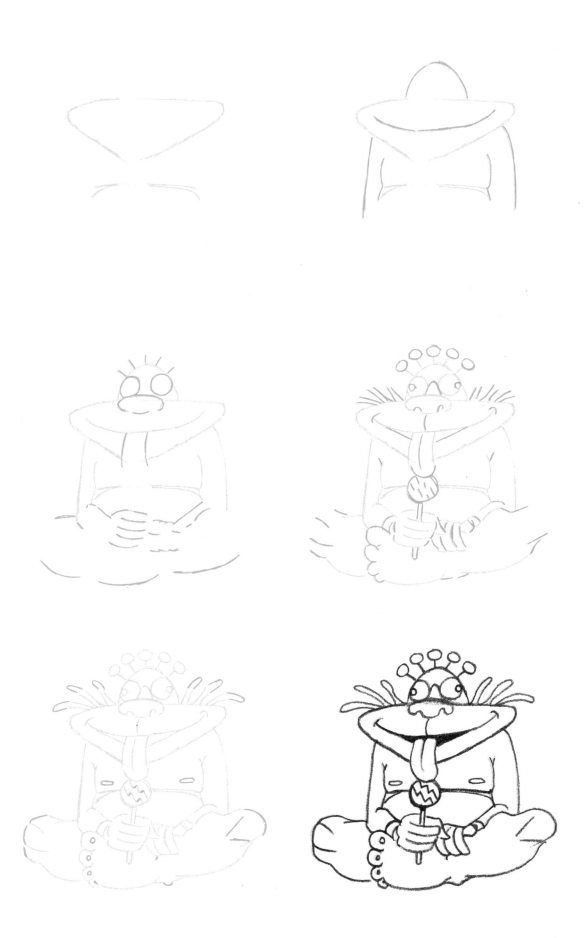

ELL LEMON OHPEE
Far-out comedian performing in amusement park near Yed Prior.

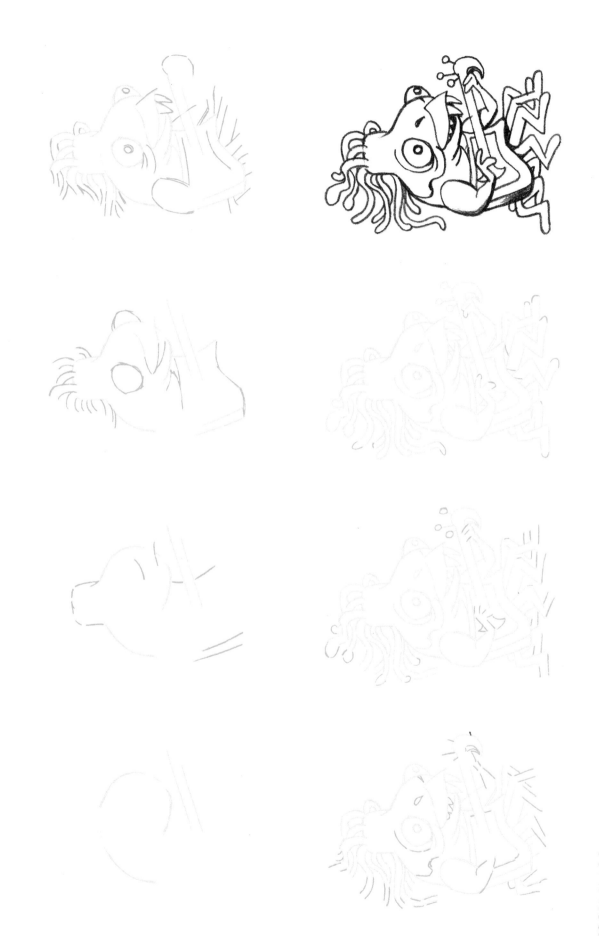

ZKIPP TOOM ALLOO
Homeless troubador from nebula in Orion.

SHMOOTZIK
Unsanitary denizen of moon of third planet of Grumium.

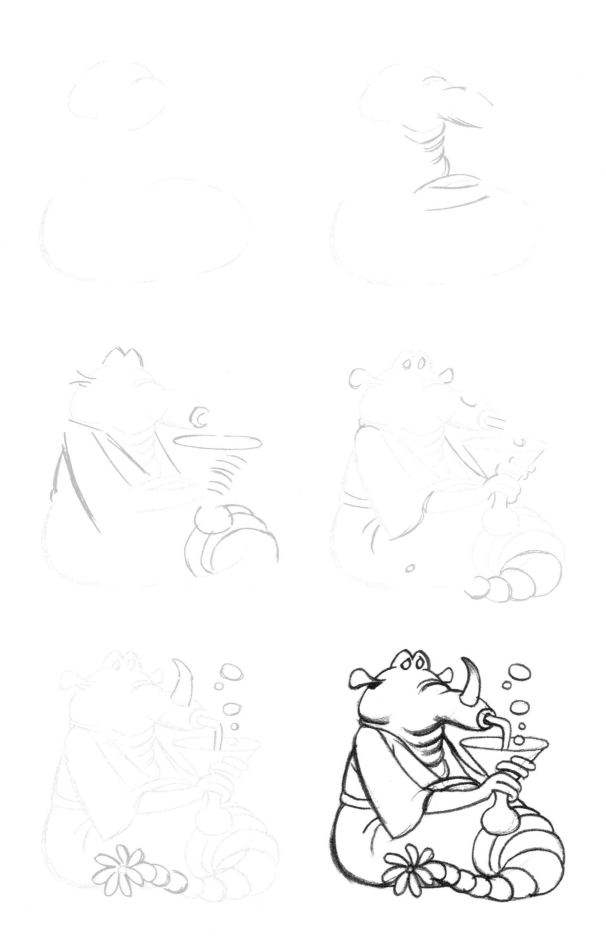

STUMBLE RILTZKIN
Seltzer sucker from carbonated water planet in Gacrux star system.

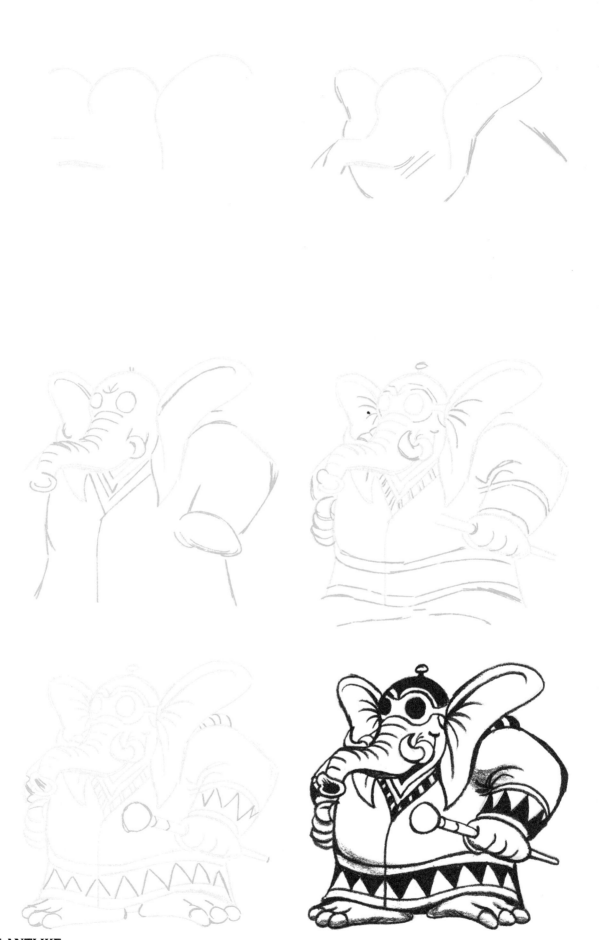

ELL F ANTLIKE
Resembles our African pachyderm but is very, very tiny. Blows poison fumes from its wee trunk. Native of a Tyl planet.

Lee J. Ames began his career at the Walt Disney Studios, working on films that included *Fantasia* and *Pinocchio*. He taught at the School of Visual Arts in Manhattan, and at Dowling College on Long Island, New York. An avid worker, Ames directed his own advertising agency, illustrated for several magazines, and illustrated approximately 150 books that range from picture books to postgraduate texts. He resided in Dix Hills, Long Island, with his wife, Jocelyn, until his death in June 2011.

Ric Estrada illustrated children's books, articles for *Dance* magazine, *Spandauer Volksblatt* and *Sonne*. He also ghostwrote the Flash Gordon and Spider Man comic strips, and created political cartoons. Estrada worked with some of the most renowned names in entertainment, such as Hanna-Barbera, Warner Bros., DreamWorks, and Sony-Columbia-Tri-Star.

DRAW 50 ALIENS

Experience All That the Draw 50 Series Has to Offer!

With this proven, step-by-step method, Lee J. Ames has taught millions how to draw everything from amphibians to automobiles. Now it's your turn! Pick up the pencil, get out some paper, and learn how to draw everything under the sun with the Draw 50 series.

Also Available:

- *Draw 50 Animals*
- *Draw 50 Animal 'Toons*
- *Draw 50 Athletes*
- *Draw 50 Baby Animals*
- *Draw 50 Beasties*
- *Draw 50 Birds*
- *Draw 50 Boats, Ships, Trucks, and Trains*
- *Draw 50 Cats*
- *Draw 50 Cars, Trucks, and Motorcycles*
- *Draw 50 Creepy Crawlies*
- *Draw 50 Dinosaurs and Other Prehistoric Animals*
- *Draw 50 Dogs*
- *Draw 50 Endangered Animals*
- *Draw 50 Famous Cartoons*
- *Draw 50 Flowers, Trees, and Other Plants*
- *Draw 50 Horses*
- *Draw 50 Magical Creatures*
- *Draw 50 Monsters*
- *Draw 50 People*
- *Draw 50 Princesses*
- *Draw 50 Sharks, Whales, and Other Sea Creatures*
- *Draw 50 Vehicles*
- *Draw the Draw 50 Way*